CUPCAKE COLORING BOOK

It doesn't matter how slow you are
As long as you don't stop

BELONGS TO

• •

complete the drawing below

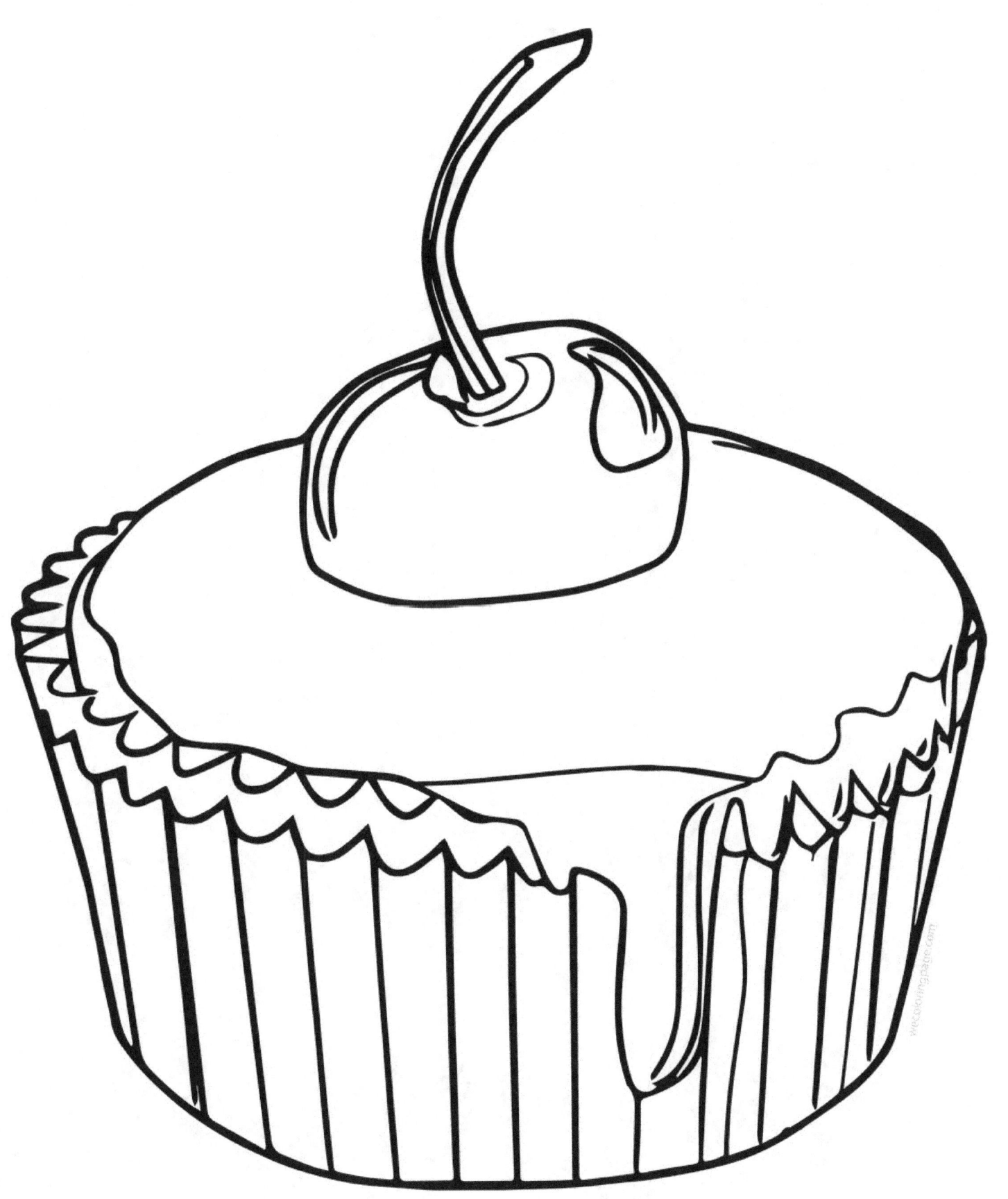

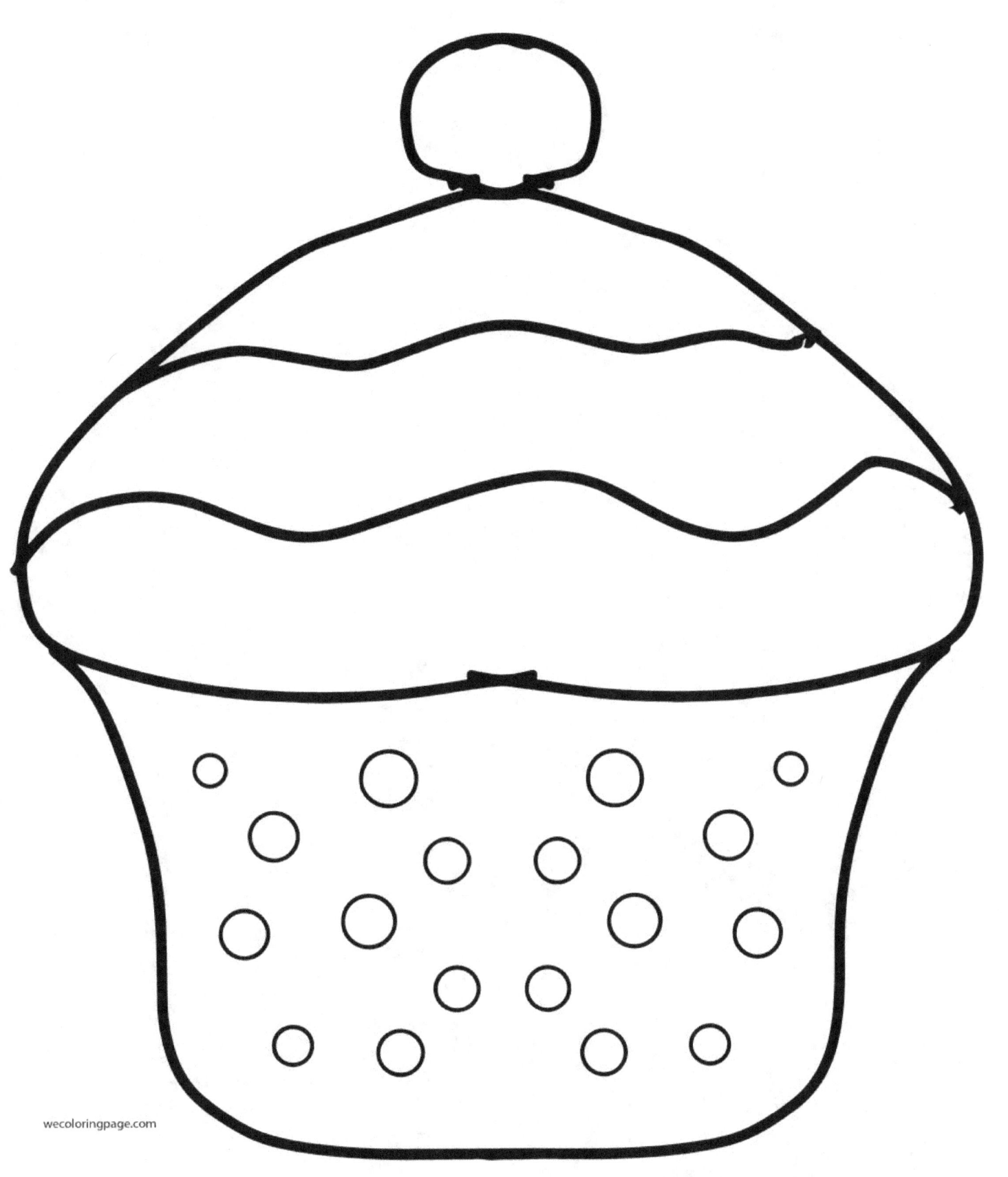

Complete the drawing below

www.ingramcontent.com/pod-product-compliance
Lightning Source LLC
Chambersburg PA
CBHW080912220526
45466CB00011BA/3557